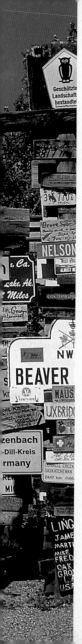

THE
ALASKA
HIGHWAY

THE
ALASKA
HIGHWAY

A
PORTRAIT
OF THE
ULTIMATE
ROAD
TRIP

ERWIN & PEGGY BAUER

SASQUATCH BOOKS

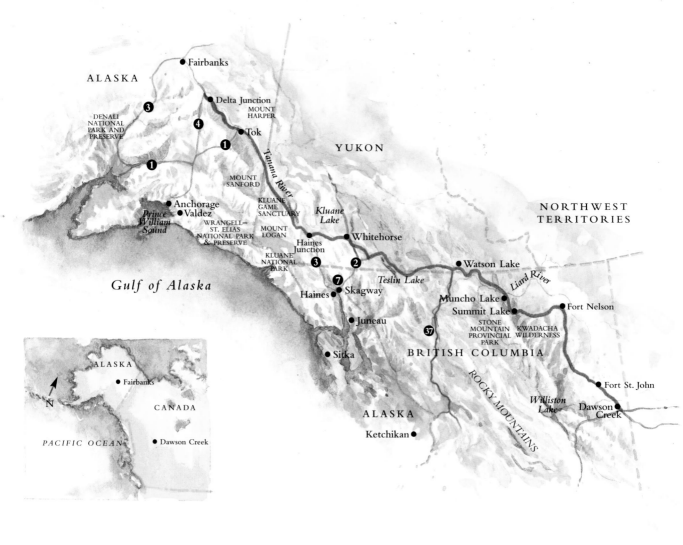

ALASKA

Fairbanks

Delta Junction
MOUNT HARPER
Tok

YUKON

DENALI NATIONAL PARK AND PRESERVE

MOUNT SANFORD

KLUANE GAME SANCTUARY

Anchorage
Valdez

Prince William Sound

WRANGELL–ST. ELIAS NATIONAL PARK & PRESERVE

MOUNT LOGAN

Kluane Lake

Whitehorse

NORTHWEST TERRITORIES

KLUANE NATIONAL PARK

Haines Junction

Tanana River

Gulf of Alaska

Haines Skagway

Juneau

Sitka

Teslin Lake

Watson Lake

Liard River

Muncho Lake
Summit Lake

Fort Nelson

STONE MOUNTAIN PROVINCIAL PARK

KWADACHA WILDERNESS

BRITISH COLUMBIA

ALASKA

Ketchikan

ROCKY MOUNTAINS

Williston Lake

Fort St. John

Dawson Creek

ALASKA

Fairbanks

CANADA

N

PACIFIC OCEAN

Dawson Creek

EARLY ON A GOLDEN SUMMER MORNING

I drove north through the Yukon Territory, marveling with my wife, Peggy, at the waist-high fireweed in full bloom along the roadside and at the snowcapped mountain range that loomed high to the west. I had to hit the brakes suddenly when a cow moose followed by a calf walked calmly across the road just ahead. Both vanished in a thicket before Peggy and I could focus cameras on them. Just a mile or so farther and still a little shaken, I had to stop abruptly again. This time a

mother grizzly bear escorted two small cubs across the road without even glancing at us.

As we watched, the bears easily climbed a steep bank and stopped on a thin ledge above the road. There the huge, brown female rolled onto her back and allowed the cubs to nurse. What followed was the nearest thing to a traffic jam in this lonely, lovely, westernmost part of Canada: three or four cars and campers— and a dozen cameras aimed and probably emptied before the three bruins eventually wandered away and out of sight.

Welcome to typical travel on the longest and greatest adventure road on the face of the earth—the Alaska Highway. From its start at Dawson Creek in northeastern British Columbia to Delta Junction in central Alaska, the route winds, climbs, and descends for 1,422 miles of spectacular, mostly pure, wilderness. Equally remarkable is that today nearly all of this road is well-graded, paved, and maintained.

It wasn't always so. I easily recall my first experience almost a half century ago, when the same area could be a dust bowl. Driving after one of the frequently heavy rains required wallowing in endless gray mud. On the other hand, there were very few motorists, and the trip was so incredible that I willingly repeated it many times.

Strange as it may seem today, the Alaska Highway is a product of a terrible war. Early in 1942, a few months after the bombing of Pearl Harbor, Japanese naval vessels patrolling the Aleutian Islands were a distinct threat to U.S. supply routes and military bases in the Alaska Territory. In fact, Japanese troops landed on Kiska Island in the Aleutians on June 6, 1942. By April, the U.S. government,

Right: *The Alaska Highway adventure begins in Dawson Creek, northeast British Columbia. It ends in Delta Junction, Alaska, 1,422 miles away.*

with Canadian cooperation, began a crash program that has been compared with the building of the Panama Canal—constructing a highway from British Columbia into Alaska.

Not every "expert" believed the overland highway was a sound idea. Some engineers and politicians labeled it an "engineering monstrosity," and most agreed it was a project that would be impossible to finish in fewer than several years. But the slogan "Either we build a highway up to Alaska or the enemy will build it down from there for us" won out. Construction officially began March 8, 1942.

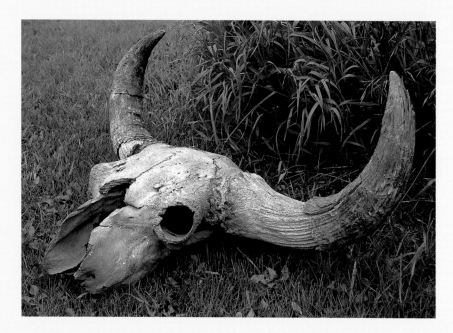

Left: *Skulls of prehistoric bison are still occasionally found near Dawson Creek. This one may be 18,000 years old.*

For eight and a half months, 18,000 troops, using an estimated 11,000 pieces of equipment, fought nearly impassable terrain, foul weather, a lack of equipment and supplies, mosquitoes, boredom, and loneliness to complete the barely passable haul road that dominated their lives. Many soldiers applied for dangerous combat duty anywhere else in the world just to get away from the muck and muskeg, from the endless bridge building and wilderness living in dreary, wet tents. The original route of what was then named the Alaska Military Highway was 1,671 miles (2,673 kilometers) long. Later it was called the Alaska–Canada Highway, the Alcan Highway, and then the Alaska Highway, after being upgraded into a shorter, all-weather route. An old sign near Destruction Bay in the Yukon (Mile 1052-1743) is correctly labeled "The Road Less Traveled." The total cost of construction was $135 million, about the same as it cost at the time to build a battleship. In recent years sections of the highway have been re-routed, shortened, and improved. It is now 1,422 miles (2,288 km) from Dawson Creek to Delta Junction.

A large road sign at Prophet River, British Columbia (Mile 233-369), offers a poem written by Troy Hise, a pioneer traveler on the Alaska Highway. It reads:

> Winding in and winding out
> Leaves my mind in serious doubt
> As to whether the man who built this route
> Was going to hell or coming out.

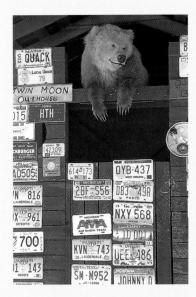

Above: *A stuffed grizzly bear watches from the crown of a "tree" in the Signpost Forest of Watson Lake, Yukon.*

Following page: *Traffic is never a problem in this lonely wilderness area.*

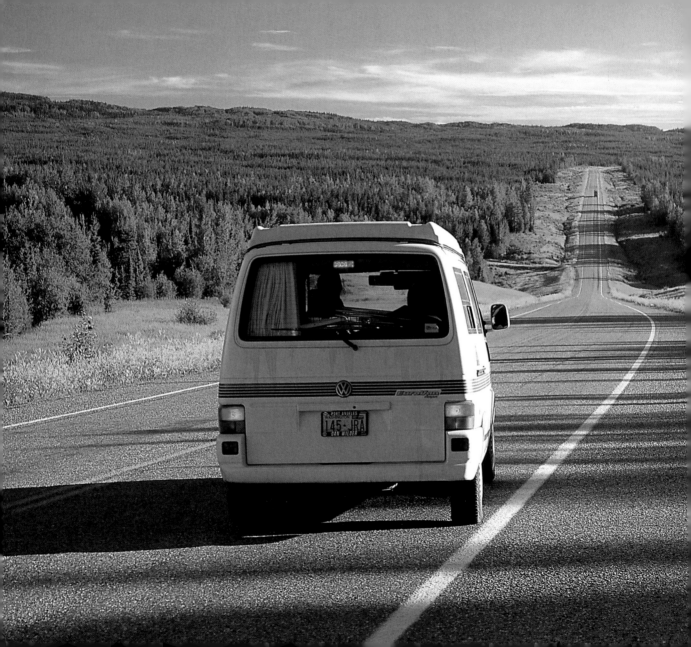

In 1942 as now, Dawson Creek (Mile 0) was the Alaska Highway's starting point because it was then the northernmost access to a railroad or airstrip in western Canada. Its population was about 500. Today, Dawson Creek is a center of good lodging, RV parks, communications, and shopping centers, with a population of 20,000. Anything necessary for the long trip northwestward can be obtained here.

The wilderness reveals itself gradually rather than suddenly. From Dawson Creek to Fort St. John (Mile 47-76), cattle ranches separate brilliant yellow canola fields in the late summer sun. Along the 300 miles from Fort St. John to Fort Nelson (Mile 283-454), human habitation gives way gradually to black spruce forests and to taiga. Attractive provincial parks and campgrounds are along this route, and travelers with camping gear can pause for an overnighter or to stretch their legs and breathe nature's fragrance. On a recent trip, Peggy and I parked our camper van for the night in a cottonwood grove at Buckinghorse Creek (Mile 173-279). All was quiet but for the quarreling of ravens and red squirrels. During an earlier trip, we listened to the howling of wolves in the distance as dusk blended into night.

Beyond Fort Nelson and its amenities lies a region of immense and spectacular beauty, a cluster of British Columbia's provincial parks where a traveler is sorely tempted to spend a few weeks. The first (and southernmost) park is 100-square-mile Stone Mountain—the highest point on the Alaska Highway. Summit Pass (Mile 393-597), at more than 4,000 feet, was not discovered until U.S. Army surveyors identified it in 1942. Today it towers above a cool campground and boat launch on Summit Lake. A network of hiking and backpacking trails

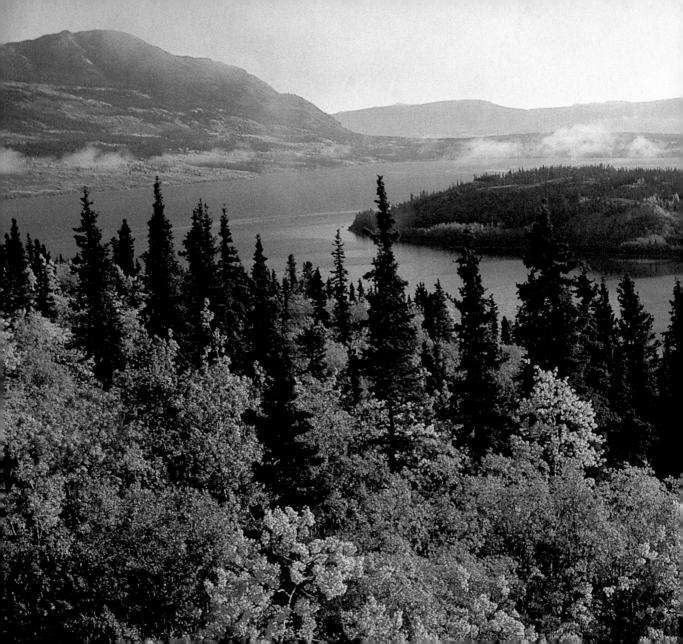

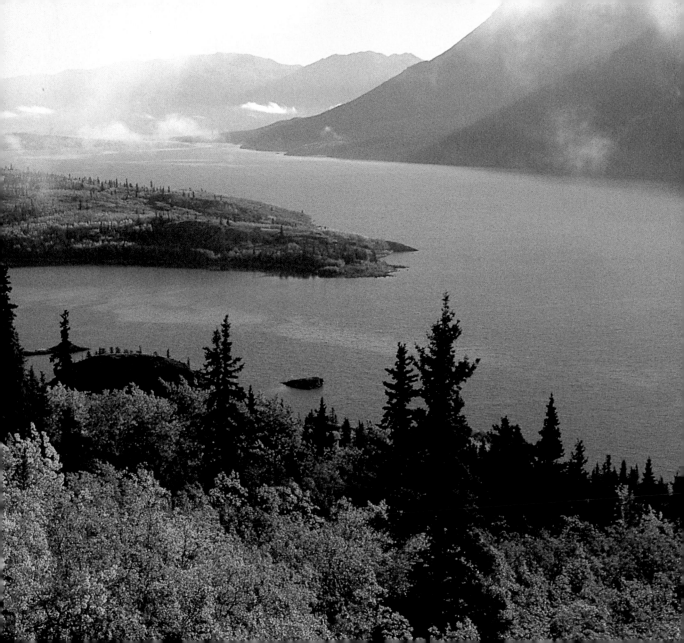

leads to many more alpine lakes and meadows. One rugged trail switchbacks to the crest of Summit Peak. Another path makes a three-mile round-trip to Flower Springs, an area of waterfalls and wildflowers.

More spectacular even than Stone Mountain is the adjoining Wokkpash Protected Area, where a two- to four-day trek leads to Forlorn Creek and the hoodoos of Wokkpash Gorge. Eroded pillars up to a hundred feet tall give the valley a mystical feeling. Not far away, a hiker can reach Forlorn Gorge, a miniature Grand Canyon that is less than a hundred feet wide but almost five times as deep.

Also in the Stone Mountain–Wokkpash vicinity (between about Mile 360-576 and Mile 400-640) is some of the most dependable wildlife-viewing on the highway. Stone sheep might be seen anywhere near here, including right on the edge of the road. This is the only place to spot mountain caribou within decent camera range. Our own list of sightings in the Stone Mountain–Wokkpash Protected Area includes black bears, deer, a pine marten, marmots, golden eagles, ptarmigan, spruce grouse, a great gray owl, and many smaller birds. Rainbow and lake trout have been stocked in Summit Lake. Most park streams contain grayling, whitefish, and Dolly Varden trout.

Not far beyond Stone Mountain, a traveler reaches Muncho Lake Provincial Park (Mile 436-698), and it is a mistake not to pause for at least one overnight at either the MacDonald or Strawberry Flats Campground beside jade-green, 12-mile-long Muncho Lake (Mile 456), or at a nearby private RV park. Muncho Lake's exquisite color comes from copper oxides leaching from bedrock into the water. The lake never warms above 50°F in high summer, but year after year it offers some of the best highway fishing for lake trout.

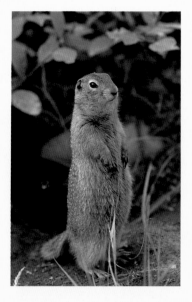

Preceding pages: *Beautiful Bennett Lake shimmers beside Route 2, which connects Whitehorse, Yukon, and the Alaska Highway to Skagway, Alaska.*

Above: *During most summers, ground squirrels are numerous along the highway, but to see mountain goats* **(right)***, it is necessary to hike deep into Kluane National Park, Yukon.*

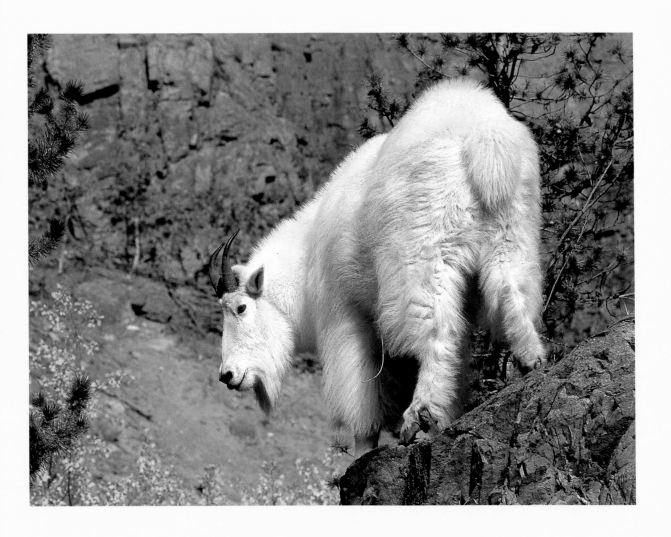

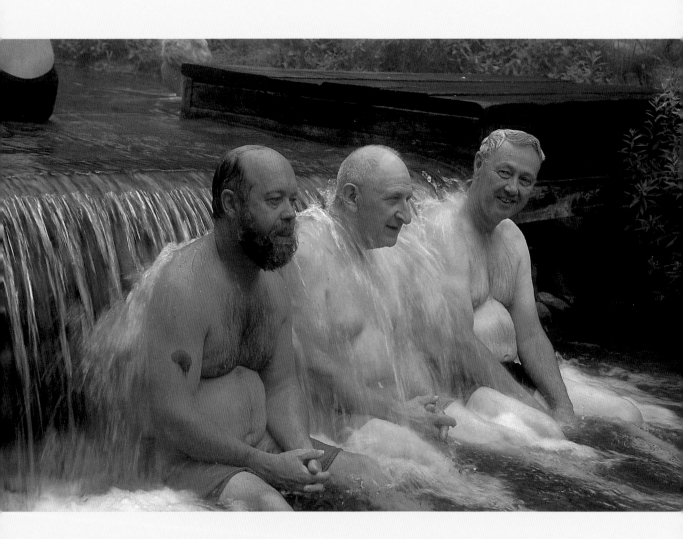

Large mammals everywhere, especially females during lactation and males during their annual growing of antlers, are attracted to mineral licks, to find sodium and other nutrients. In very few places are the licks as accessible and the wildlife-viewing so easy as at two well-marked Muncho Park sites. Especially in spring through early summer, early and late in the day, Stone sheep, caribou, and moose, as well as wolves and grizzly bears, are regular and unwary lick visitors. Not far from the mineral licks, the big animals graze in a rich plant community that contains bog orchids and a rare yellow species of lady slipper.

Say you have spent a few days exploring Stone Mountain and Muncho. Maybe your leg muscles are sore from the hiking or you simply need a break. Total relief is waiting in a mini-paradise that local Kaska Indians, a few trappers, and some gold prospectors discovered long ago, only an hour or so up the highway at a place now within Liard River Hotsprings Provincial Park (Mile 792). There, in a boreal spruce forest, are a marsh and Canada's second largest hotsprings ecosystem, an unexpected island of moist warmth totally unlike the surrounding area. Mineral-rich hot water boils to the surface, forming two natural bathing pools surrounded by terraces that have an oddly tropical look, where ostrich ferns, cow parsnip, carnivorous sundew, butterwort, and aquatic bladderwort grow in hanging gardens. Even a reptile species, the northwestern boreal toad, survives on warm swamp edges.

Liard's wooded 53-unit campground may be the best bargain on the entire highway. For the nominal cost of a tent, trailer, or motor-home site, you get free campfire logs and unlimited soaking time in the hot pools connected to the campground via a boardwalk. It is no wonder that every day you meet many

Left: *Liard Hotsprings in northernmost British Columbia has been soaking and soothing travelers since the highway was built.*

visitors—bathers, that is—from Europe, Japan, and every corner of North America luxuriating in the 95°F to 110°F pools.

Driving, perhaps reluctantly, northwestward from Liard, travelers are often delayed by something other than seasonal road repairs. Buffalo were recently reintroduced into this region just beneath the Yukon Territory border (about Mile 570-912). Now a healthy herd roams freely there, and at times that roaming is right beside or in the middle of the road. In any case, it's a thrill to pause and watch these giants that once were in danger of extinction, especially if the late summer breeding season is underway.

Upon crossing into the Yukon Territory (Mile 608-976), the first sign of civilization is the town of Watson Lake (Mile 613-1021), a good place to resupply groceries. Visitors passing through Watson Lake invariably do a double take and stop to explore a "forest" vastly different from anything seen so far. In 1942, a homesick U.S. Army soldier working on the highway erected a sign stating the exact mileage to his hometown in Iowa. Since then, 30,000 other happy travelers from Anaheim to Zimbabwe have left behind similar markers and license places fabricated into a garish but compelling Signpost Forest. Not far beyond the "trees," Peggy and I like to stop at the Wolf It Down restaurant to buy enough hot pastries for the four and a half hour drive onward toward Whitehorse.

Just a few miles west of Watson Lake and near Upper Liard (Mile 648) is the important junction with the Cassiar Highway, another wilderness road that meanders due south and dead-ends at Prince Rupert on British Columbia's Pacific Coast. Cassiar travelers can either join or leave the Alaska Highway at Upper Liard.

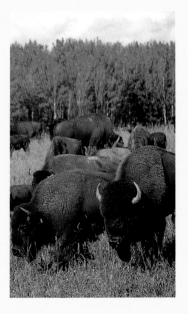

Right and below: *Travelers often must slow down or stop for the wild bison that roam freely along the Yukon–British Columbia border.*

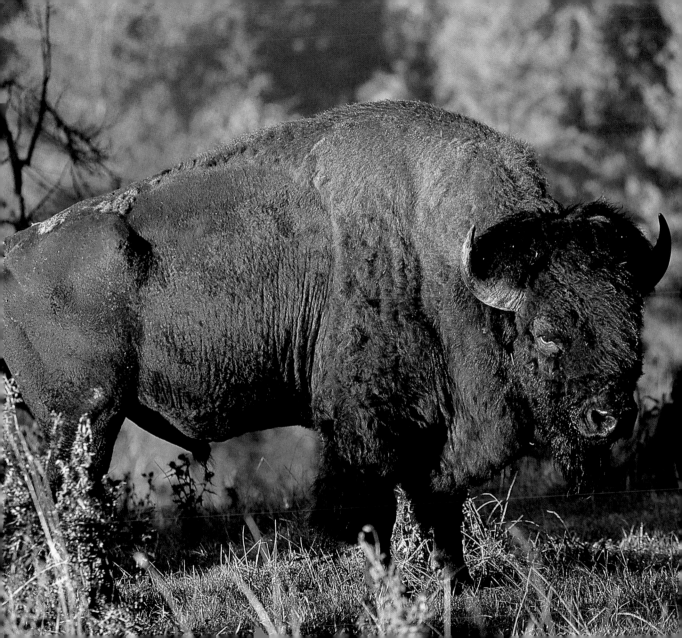

For about twenty miles beginning at Mile 776-1294, the Alaska Highway closely parallels the north shore of Teslin Lake. At intervals along the lake lie secluded campgrounds, snug rental cabins, and resorts offering guides and outfitters. This is an ideal place to unhitch a cartop or trailered boat to try the fishing, which remains good throughout the summer. Early every springtime great migrations of waterfowl, especially trumpeter and tundra swans, concentrate in a few ice-free places along Teslin's shore, where they are easy to see. Here, as elsewhere in the Yukon Territory, a free copy of *Yukon's Wildlife Viewing Guide* (see "Select Bibliography" on page 78) is available at all visitor reception centers.

A serious lover of the outdoors might well spend an entire summer exploring the area around Teslin Lake. Near Wolf Creek Campground, for example, salmon can be seen spawning during July and August in the cold, clear riffles of Wolf Creek. It's an especially compelling sight because these fish have traveled almost 1,000 miles nonstop up the Yukon River from the ocean. After spawning, they die here.

Throughout the Yukon's portion of the highway, roadside signs indicate stocked lakes where rainbow trout are regularly released. All the ponds are easily accessible for casting from shore, but canoe fishing is much more productive. The ticket to fish is a valid Yukon license.

At Mile 874, Yukon Route 2, the paved Klondike Highway, joins the Alaska Highway just south of Whitehorse, at Carcross Corner. This is an important junction for travelers who prefer not to drive the entire Alaska Highway in both directions. Instead of driving the route north from Dawson Creek, they can board the twice-weekly Alaska Marine Highway car ferry in Bellingham, Washington,

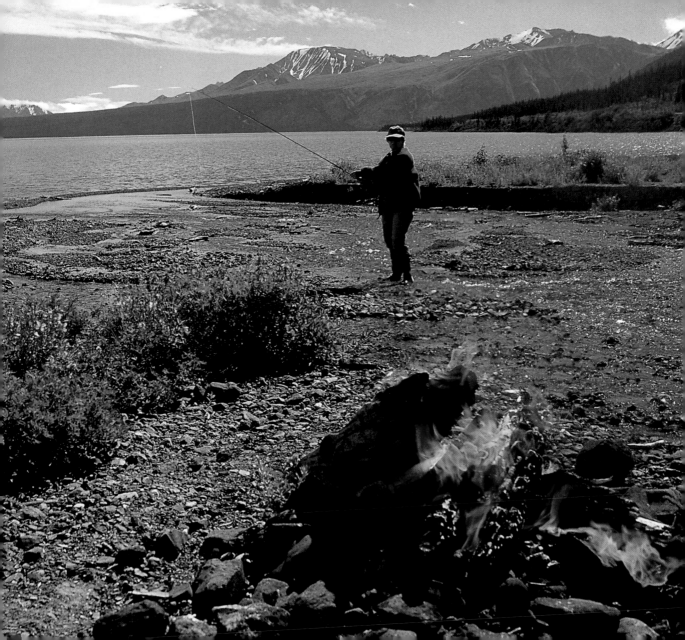

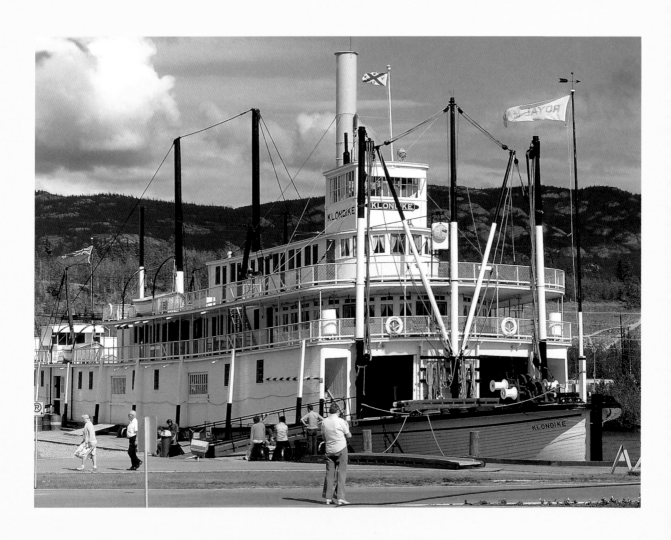

Previous page: *On a cool evening an angler flycasts within sight of the campground and his campfire beside Kluane Lake.*

Left: *The steamboat* Klondike, *which once carried gold miners up the Yukon River to Whitehorse, is now retired, restored, and open to visitors.*

Below: *A vagabonding canoeist-fisherman pauses to savor a sunny afternoon at Square Lake Campground, Yukon.*

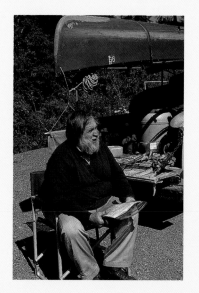

and cruise through the Inside Passage to Skagway, Alaska. From Skagway, they can take the year-round Klondike Highway to join the Alaska Highway, following the scenic trail of 1898 gold stampeders for about 100 miles and often within sight of the still-operating, narrow gauge White Pass and Yukon Railroad.

Or, when traveling southward back to the Lower 48, motorists can leave the Alaska Highway at Mile 874 and drive Route 2 to Skagway, where the three-day ferry trip back to Bellingham begins. This saves repeating the 874-mile drive back to Mile 0 at Dawson Creek.

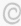

A century ago, some 30,000 desperate fortune seekers literally fought their way slowly up the Yukon River by boat to reach the newly discovered goldfields. One of the most perilous passages was a wild rapids section that reminded the stampeders of the manes of white horses. That place is the city of Whitehorse, today the capital of Yukon.

After miles of wilderness driving, Whitehorse (Mile 884-1470) is certainly a change of pace. While a turn-of-the-century aura hovers over the contemporary city of 24,000, it is thoroughly modern, attractive, and busy, especially during summer when the days are very long and usually sunny and bright. Whitehorse has excellent lodgings and restaurants, craft shops and museums, summer festivals, and the best book shop (the Fireweed) in all of northern Canada.

Visit the SS *Klondike,* a restored Yukon River paddle-wheel steamboat. Hike the trails overlooking the river or take a raft trip through scenic Miles Canyon. Nearby visit the world's longest wooden fish ladder, with underwater viewing

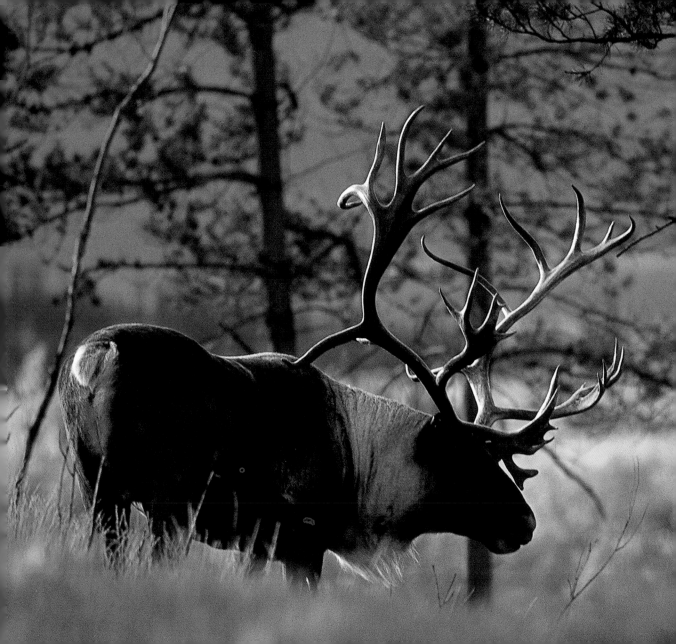

Left: *Stone Mountain Provincial Park, B.C., is anyone's best bet to see a handsome woodland caribou bull such as this one.*

Right: *An Alaska Highway journey without pausing for a salmon bake is like summer without wildflowers.*

windows for watching the upstream migration of Yukon River chinook salmon, trout, inconnu (sheefish), grayling, and long-nosed suckers. The Yukon Beringia Centre beside the Alaska Highway in Whitehorse is a dramatic display of Yukon's Ice Age past. End a Whitehorse visit at the Frantic Follies, a burlesque of entertainment and dance-hall girls from the turbulent days of the gold rush.

Northwest of Whitehorse, the Klondike Highway forks northward (Mile 895-1847) toward Carmacks and Dawson. It is worth taking a short detour onto this route to Takhini Hot Springs and its thermal pool, pancake breakfasts, horse

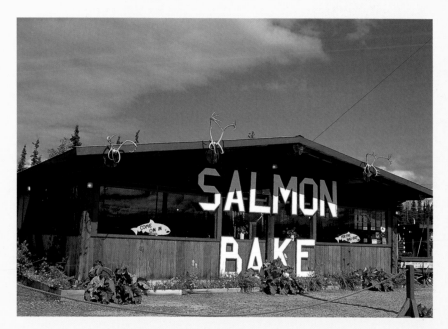

trail rides, summer salmon bakes, and wooded campsites. Almost adjacent to Takhini is the 700-acre Yukon Wildlife Preserve, any traveler's best bet for watching at close range all of the hooved, horned, and antlered big-game species of the Yukon Territory, including muskoxen.

When continuing on the Alaska Highway toward Haines Junction, watch for elk along the road and for the first views of the mountains looming above Kluane National Park. I always pause at the park's visitor center (Mile 985-1635) for trail and wildlife-sighting information. Nearby, Peggy and I (as well as others, every summer) once began an extraordinary twelve-day float trip down the remote Alsek River to tidewater Dry Bay on the Pacific Ocean. At Haines Junction (Mile 985-1635), some travelers take a turnoff road south to Haines, Alaska, perhaps to make connections with the Alaska ferry system.

The wanderlust and wonderlust really take hold when you head north from Haines Junction. There is no other connecting road for 260 miles until Tetlin Junction (Mile 1302-2095), well inside Alaska. Trip after trip, it is here that I always recall the lines from Robert Service's *Spell of the Yukon:* "It's the great, big, broad land 'way up yonder. / It's the forest where silence has lease. / It's the beauty that fills me with wonder. / It's the stillness that fills me with peace."

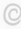

The Alaska Highway is the eastern boundary for 150 miles of Kluane National Park and Wildlife Sanctuary. Although not as well-known as the more accessible Canadian parks of Banff and Jasper, Kluane is an equally splendid masterpiece of nature. It protects Canada's highest mountains and the world's largest non-polar

The lynx **(below)** *and muskoxen* **(right)** *are examples of wild creatures that inhabit the lands surrounding the highway, but that are difficult to see. The muskoxen live on the Yukon Game Farm and Wildlife Preserve near Tahkini Hot Springs, Yukon.*

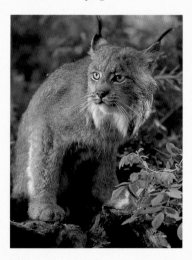

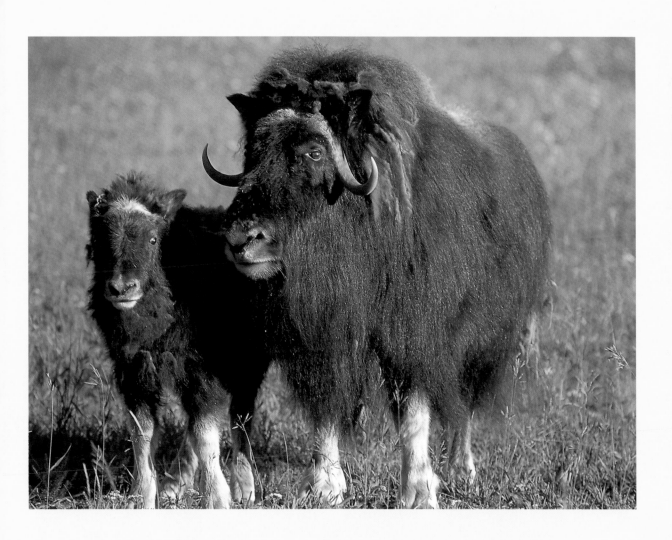

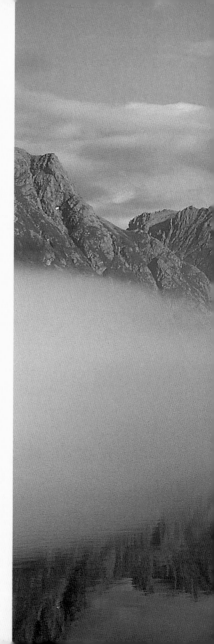

icefield. Combined with Glacier Bay and Wrangell–St. Elias National Parks in
Alaska and Tatshenshini–Alsek Wilderness Provincial Park in Canada, Kluane was
designated a World Heritage Site in 1992 by the United Nations. Its combined
24 million acres make it the largest internationally protected area on earth.

Without fail, I drive more slowly with Kluane's magnificent Front Range
mountains on my immediate left and Kluane Lake to my right. This is a good
stretch to watch for grizzly bears, and especially for all-white Dall sheep, except
during drier, warmer midsummers when both retreat out of sight to higher,
cooler elevations. It is difficult to pass up the camping and fishing opportunities
along the lakeshore, so we linger, especially around Burwash Landing (Mile
1061-1759), where there is a fine wildlife museum, and in Destruction Bay
(Mile 1034-1717), a native community once leveled in a savage windstorm.
We always hit the hiking trails, especially during July's wildflower blooming sea-
son, but we know we could never leave footprints on half of the trails, even if
we devoted a lifetime to it. A number of outfitters offer helicopter lifts over
and into the backcountry, and hikers can be airlifted to distant areas from which
they return on foot.

Flightseeing from Burwash Landing is the easiest way to see Canada's highest
peak, Mount Logan (19,545 feet), which many international mountaineers try
to climb each year. Unfortunately, the high mountain range next to the Alaska
Highway blocks views of Mount Logan and distant icefields.

We will never forget one clear, cold evening when, camped beside St. Elias
Lake after a day of hiking, we watched for a long time as pink and green light
waves exploded across the black night sky. We knew that the northern lights,

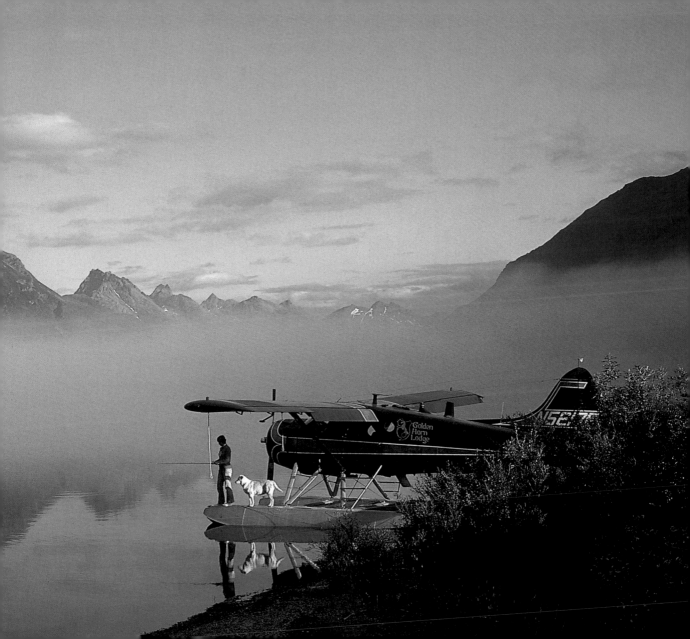

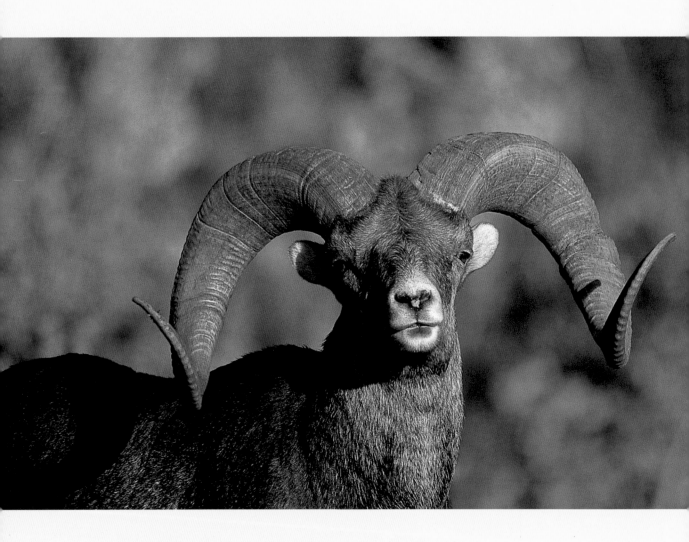

Left and below: *Stone sheep like these rams may be spotted early or late in the day in Muncho Lake Provincial Park, B.C.*

Preceding page: *From Burwash and other points on Kluane Lake, planes can be chartered for fishing trips to even more remote wilderness centers.*

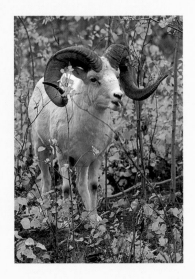

or aurora borealis, occur when solar wind particles collide with our planet's magnetic field—but the display that night was simply awesome, and scientific explanations were far from our minds.

A short list of the best Kluane hikes would include the Rock Glacier Interpretive Trail, where a rock layer covers an ice core grinding mysteriously beneath it. A much longer trail leads to Lowell Glacier, one of the valley's largest. The Auriol Trail is a nine-mile traverse of moose, bear, and berry country. Another walk ends at Klukshu Salmon Camp, where in late summer Tlingit natives catch (in traditional traps), dry, and preserve the fish. Many short trails start near the Sheep Mountain visitor center, where backcountry hikers can borrow bear-resistant food canisters or watch bears and Dall sheep through a spotting scope.

From Kluane Country to Beaver Creek (Mile 1169-1935), the Alaska Highway swings due north after crossing the braided White River, where wolves are often seen hunting. Among the targets of these canines are siksiks, or Arctic ground squirrels, which some summers are extremely abundant and found right next to the road, and other summers are scarce. Beaver Creek is Canada's westernmost community, and the Alaska–United States border city, Port Alcan, is just beyond at Mile 1222-1966. Soon after passing through customs, a traveler enters the 924,000-acre Tetlin National Wildlife Refuge.

Unfortunately, there is little easy access to this vast and wild sanctuary, which is an important waterfowl and shorebird nesting area where wolves, moose, and Dall sheep also live. At only one place, the handsome log visitor center, is there a panoramic view of the vast refuge.

Just a few miles beyond Tetlin visitor center (Mile 1249) lies Deadman Lake State Park and its unique camping area. Situated over permafrost—frozen ground that never thaws—the scene is almost surreal. Trees arch over the entrance road, concrete fireplaces at campsites are sunken, and toilets are elevated. The heat from the campfires built in the firepits on level ground has melted the permafrost below, causing the concrete to slowly sink. Frost action, which expands the turf below the privies, thrusts them upward a few inches each year. Now a short climb is necessary to reach the outhouse door! Regardless, there is good fishing for northern pike in Deadman Lake, and a boat launch site makes it accessible.

At Mile 1314 the road enters Tok (rhymes with "poke"), known as the Sled Dog Capital of Alaska. For many it may also be the end of the Alaska Highway as they turn south on Alaska Route 1 toward Valdez and the Prince William Sound area. Either way, Tok is a convenient place to stop to satisfy any travel needs from lodging to restaurants, from information to auto maintenance. A number of especially fine RV parks are located in town. The sled-dog theme is everywhere, and the Burnt Paw store offers free nightly demonstrations of the valuable animals, the sleds (which run on wheels during summer), sledding lore, and traditional mushing.

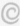

From Tok, the Alaska Highway roughly follows the Tanana and Little Tanana Rivers. Near Lake George it begins a nearly straight run of forty-five miles, crossing the Trans-Alaskan Pipeline just southeast of the end at Delta Junction

Right: A cartop canoe can be extremely useful to highway travelers. The light craft makes it possible to pause and explore hundreds of lakes and streams that lie within reach of the road.

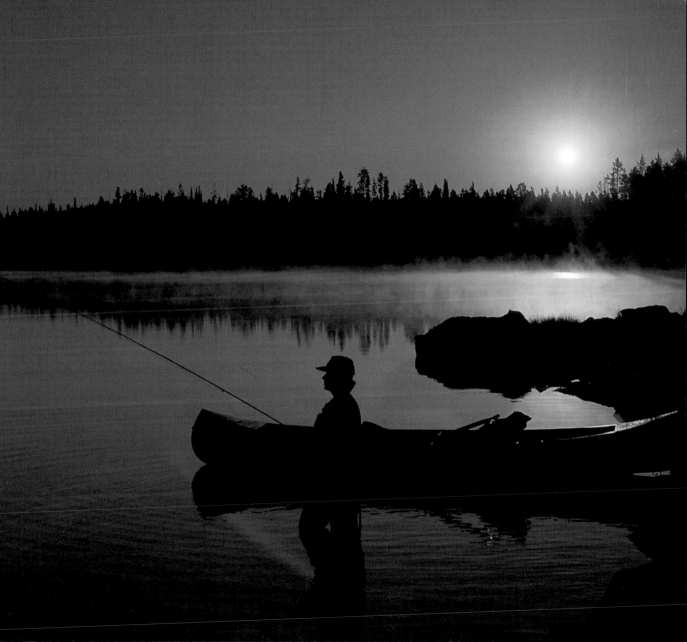

(Mile 1422-2288). For many, arrival here is a bittersweet end to a journey they couldn't possibly forget. For others in a hurry, and those who do not relish wild places and wild beauty, it probably concludes an ordeal. From Delta Junction, Route 2 continues to Fairbanks and onward via the Parks Highway to incomparable Denali National Park. After resting, fishing, or viewing the nearby buffalo herd, drivers can turn south toward Anchorage and more populated parts of Alaska.

Although the Alaska Highway is open year-round, winter travel can be unpredictable, if not hazardous at times. Naturally, the busiest season runs from June through late August, when the entire landscape begins to change from green to red and gold. In many places in North America the colors of autumn are stunning and the atmosphere is invigorating and crisp, but that "engineering monstrosity" from central Alaska to northeastern British Columbia may take you through the most brilliant and haunting seasons anywhere. Early September is *the* time to savor the Alaska Highway. And besides, the mosquitoes of summer are gone.

Having wandered and photographed widely around the world with the perfect traveling companion, for this writer the Alaska Highway is an adventure road and a wilderness experience beyond compare. I'll have to get back there again soon.

Left: *In early September, autumn descends on the Alaska Highway, making it more spectacular than ever.*

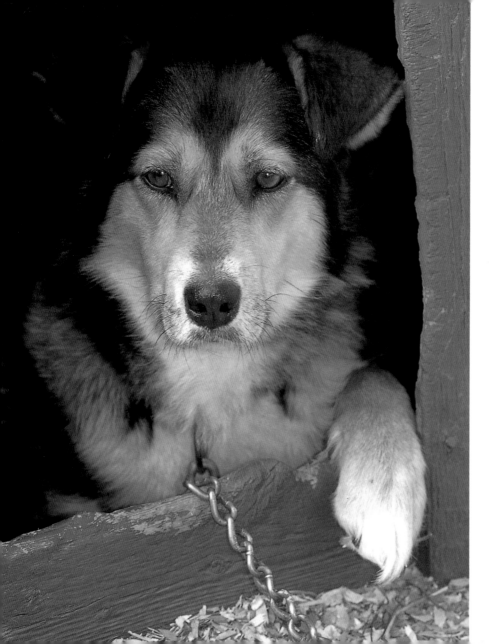

Left: *Almost as many sled dogs as people live along the Alaska Highway. This one waits for the arrival of winter snows.*

Right: *During summer near Tok, Alaska, this dog is a backyard sentinel.*

Right, bottom: *A neat log cabin, with a fire glowing inside, is a cozy retreat during a late summer rain.*

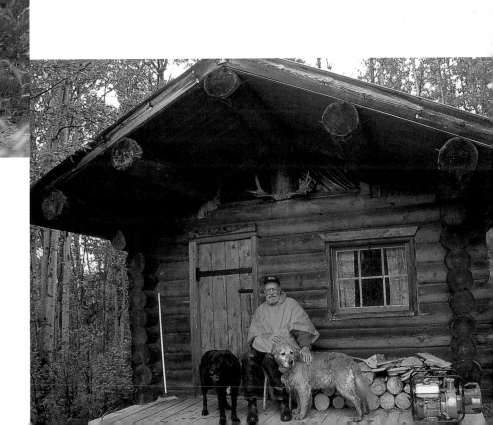

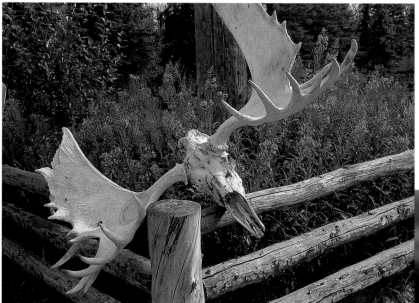

Left: *Moose skull and antlers mark the corner of an Alaskan homestead, overgrown with summer's fireweed.*

Below and right: *In August, fields of fireweed dominate many miles of roadside from the beginning to the end of the highway.*

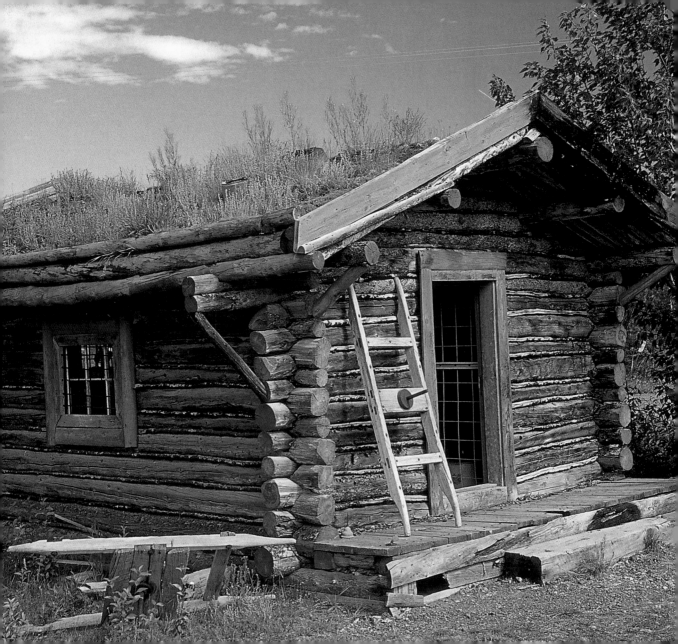

Left: *Old sod-roofed log cabins, like this one at Burwash Landing, still stand as a reminder of the highway's past.*

Right: *An adjunct to every old homestead is the food cache, erected on stilts to be bear-proof.*

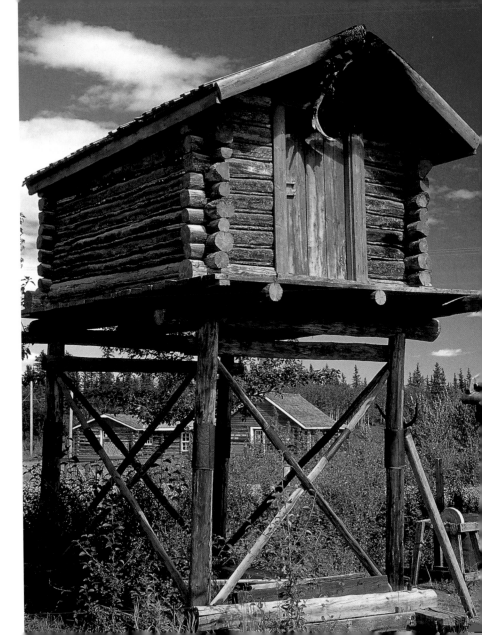

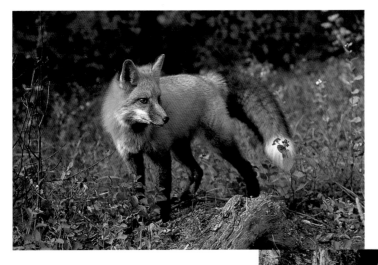

Left: *A red fox watches traffic pass on the highway near Coal River, B.C.*

Below: *Kestrels just out of the nest wait to be fed near a Fort St. John, B.C., campground.*

Right: *Although not often encountered, wolves might be seen anywhere along the highway, as here on the flats surrounding Kluane Lake.*

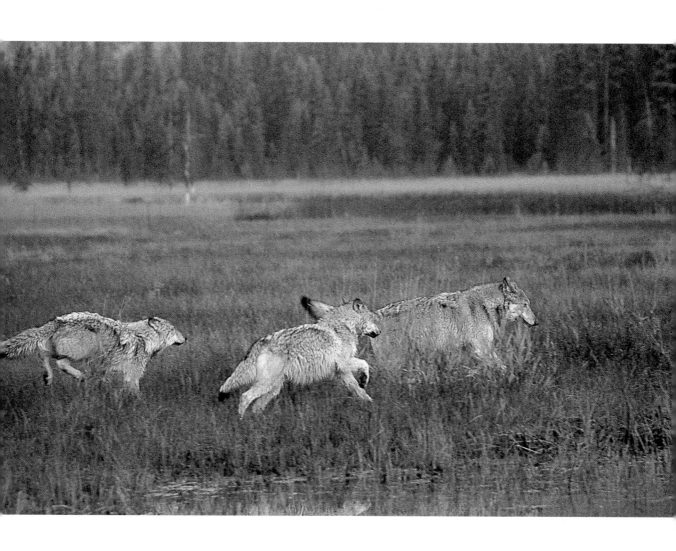

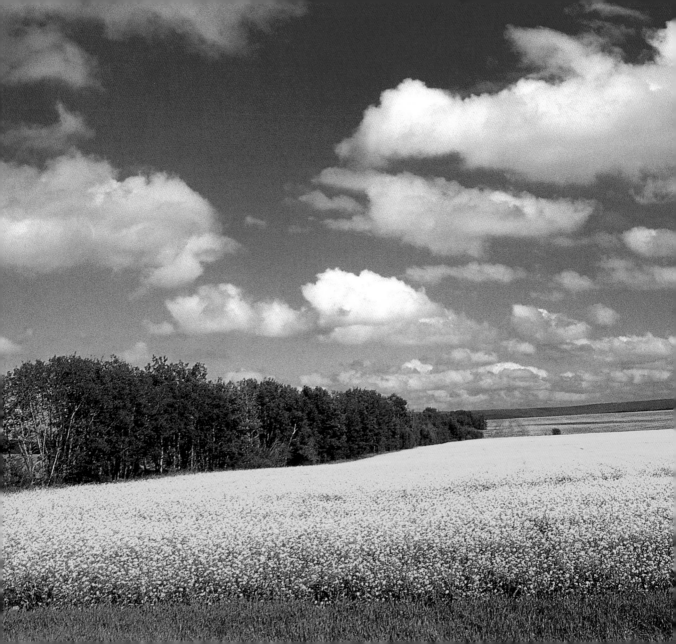

Far left: *Canola fields, blossoming yellow in summer, are interspersed with ranchlands just north of Dawson Creek, B.C.*

Left: *Scarlet paintbrush is a common wildflower of summer in Yukon and British Columbia.*

Below: *A flower wagon, a sign of hospitality, marks the entrance to a roadside bed and breakfast.*

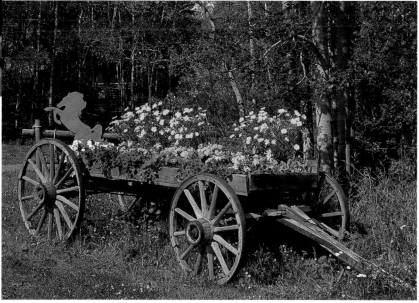

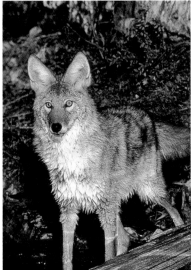

Among the larger mammals likely to be encountered along the highway are the coyote **(left)**, *the grizzly bear* **(below)**, *and the caribou* **(right)**. *The best place to photograph a caribou is between Stone Mountain and Muncho Lake Provincial Parks in B.C.*

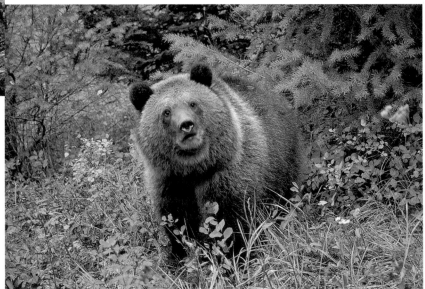

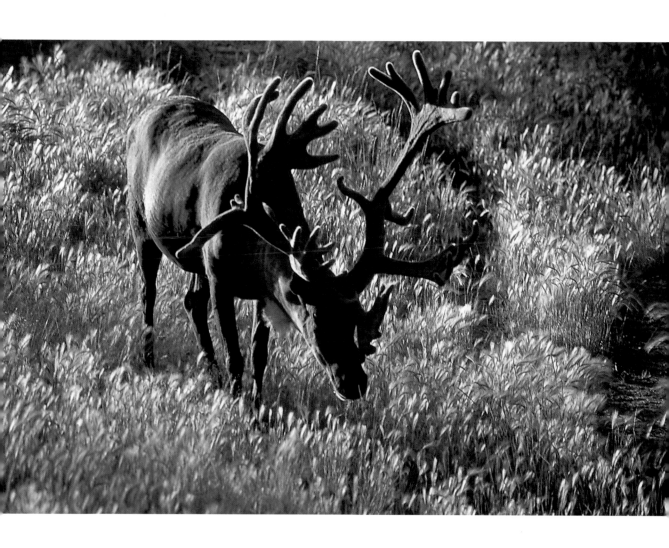

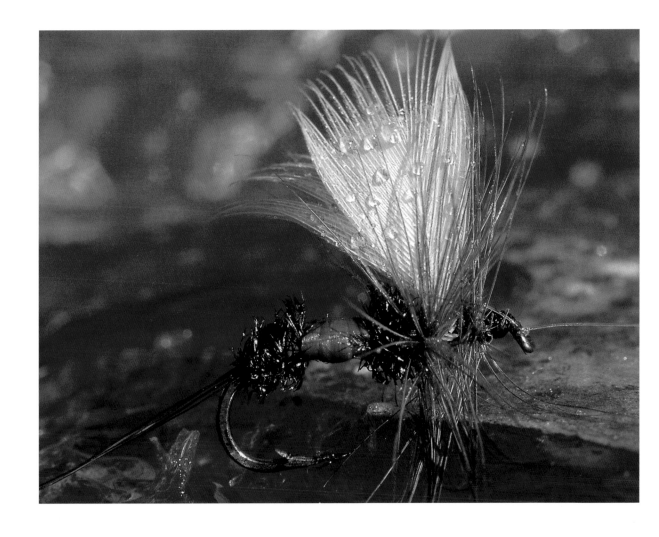

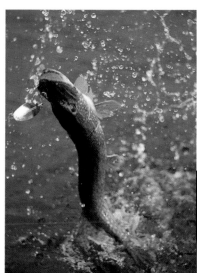

Far left: *Fly fishing for trout can be exciting in waters accessible from the highway.*

Left: *A northern pike leaps from the cold water of Deadman Lake, Teslin National Wildlife Refuge, Alaska.*

Below: *This rainbow trout was caught where the highway crosses a small Yukon waterway.*

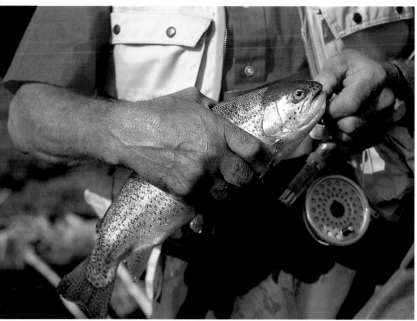

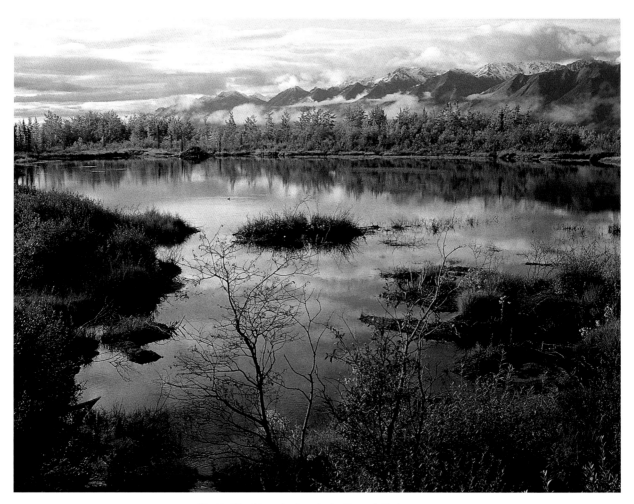

The St. Elias Mountains loom in the distance behind
this quiet Kluane pond impounded by beavers.

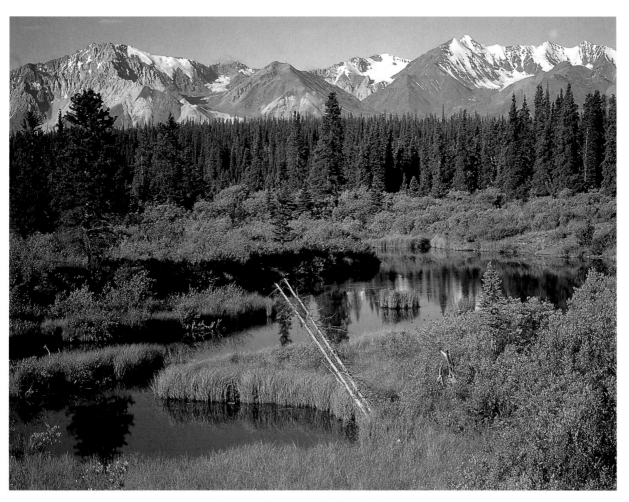

*Early autumn is beginning to color the wetland
edges in Yukon's magnificent Kluane National Park.*

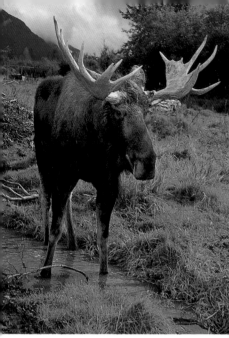

Left: *In Alaska, the mammal most likely to cross the highway in full view is the moose.*

Below: *The great gray owl is fairly tame, and in the summer it can be seen during the day, hunting mice along the edges of the forest.*

Right: *In many campgrounds, pine martens are active hunters in the trees and on the ground.*

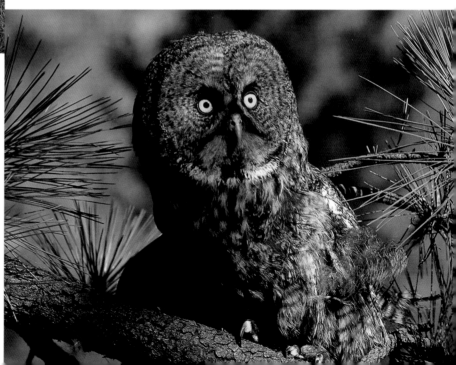

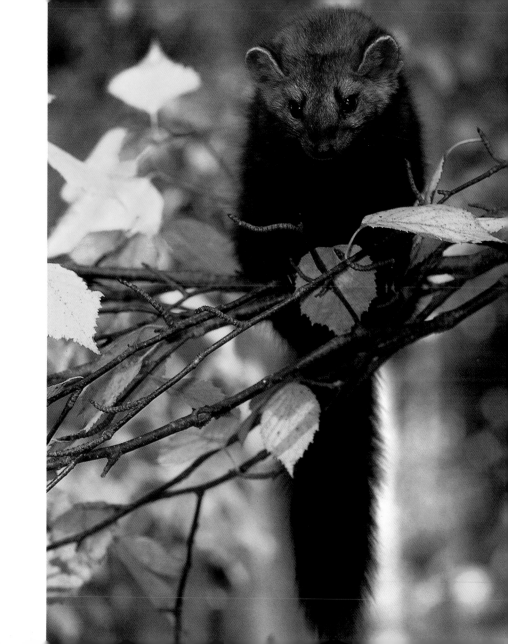

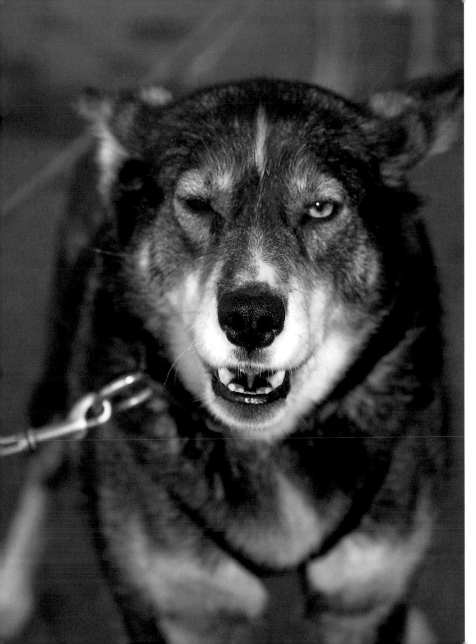

Left: *This sled dog was a little cranky after being awakened by travelers.*

Right: *Craft shops are open and artisans busy in every community along the highway. This eagle, on display in one of the shops, was carved from a moose antler.*

Far right: *Beaded caribou-hide moccasins are popular gifts to take home.*

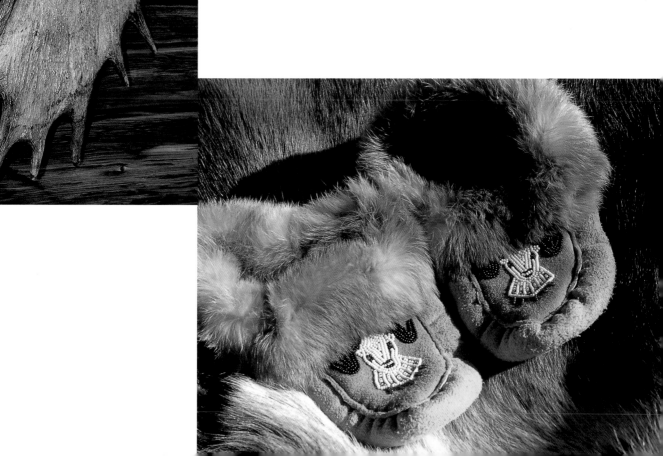

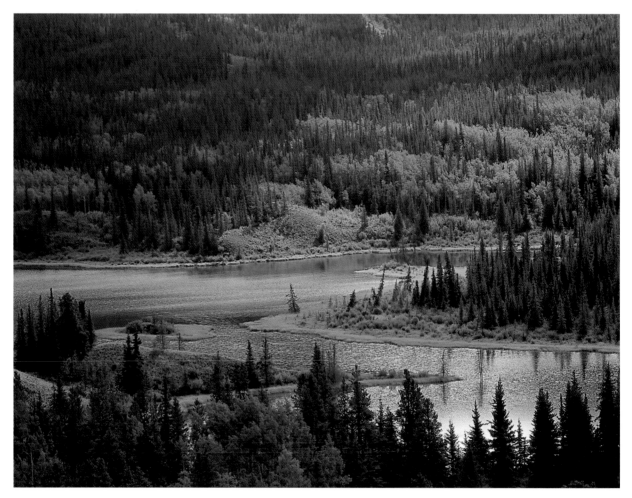

*The highway winds through Yukon's Shakwak
Valley, a likely area for encountering moose.*

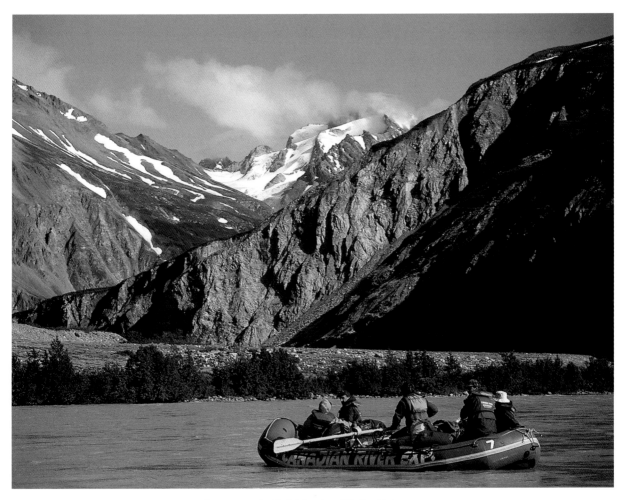

Float trips on the Alsek **(above)** *and Tatshenshini Rivers begin near Haines Junction and end where the rivers empty into the Gulf of Alaska.*

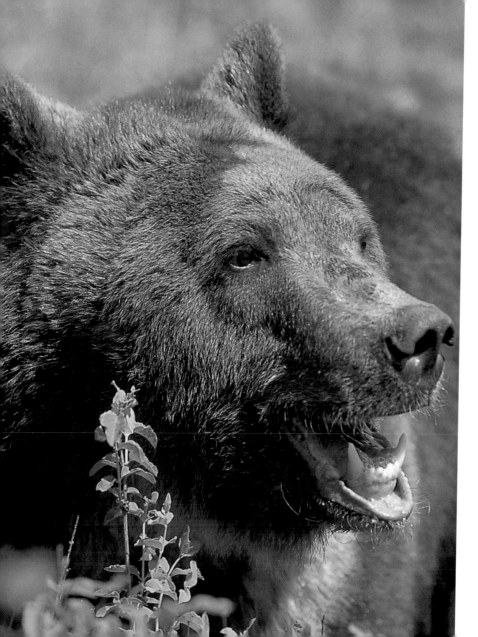

Left: *This grizzly shows his impressive canines near Kluane Lake.*

Right: *A grizzly adult walks along a salmon-spawning stream near Teslin Lake, Yukon.*

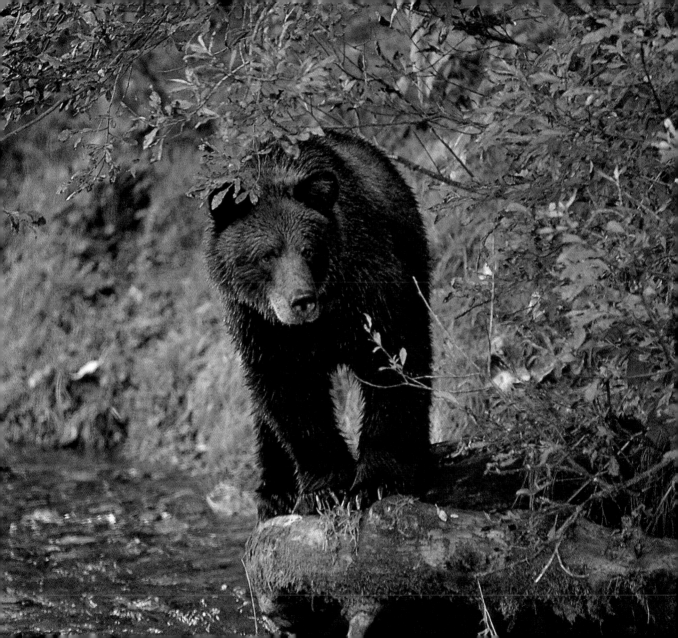

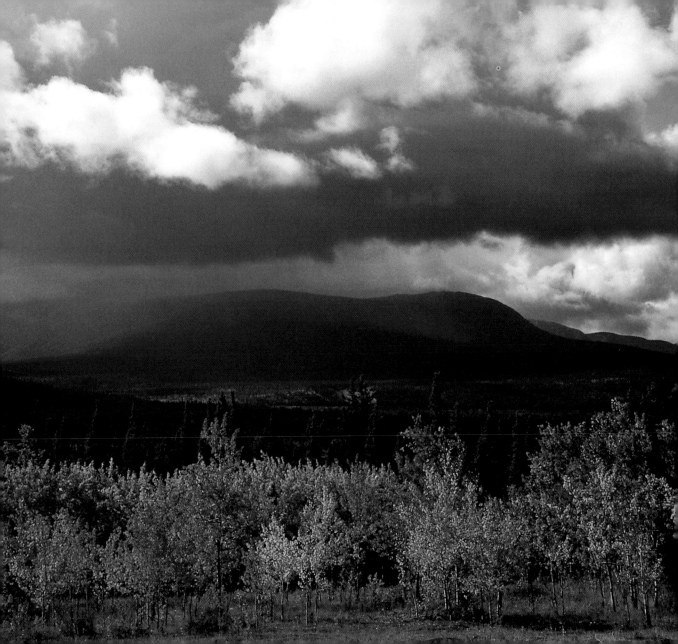

Left: *Glorious fall colors are illuminated as thunderclouds darken the St. Elias Mountains in Kluane National Park.*

Below: *Aspen leaves change quickly from green to red and yellow as August blends into September.*

Right: *Some years colorful but inedible Amanita mushrooms grow along lowland hiking trails.*

Left: *Commercial river runners advertise float trips near Taylor, B.C.*

Below: *By midsummer around Jakes Corner, Yukon, racks of salmon hang in the sun to dry.*

Right: *A golden retriever waits for his best friend at one of the highway's most distinctive outhouses, near Dawson Creek, B.C.*

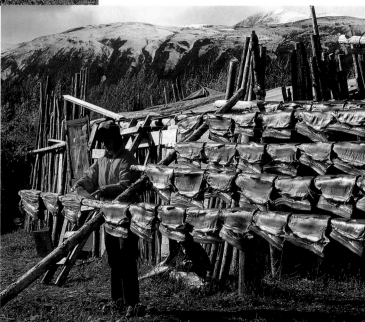

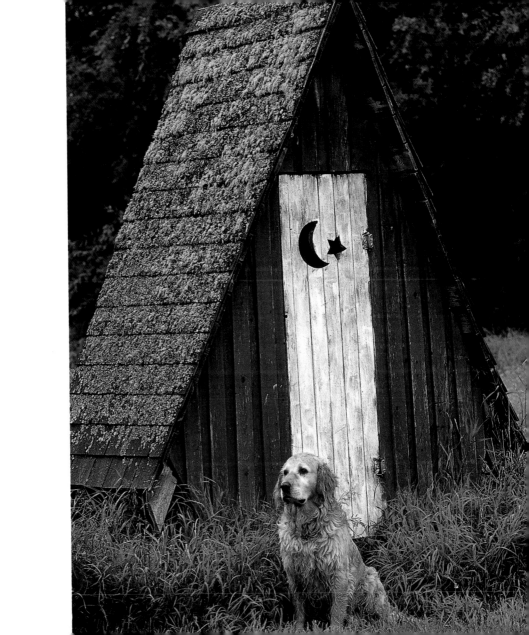

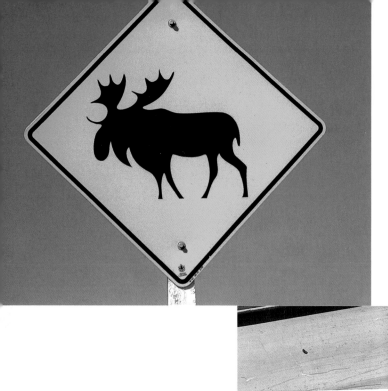

Left: *An area of frequent moose crossings is marked with a stylistic warning sign.*

Below: *A poignant memorial is added to the 30,000 signs ("foliage") in Watson Lake's Signpost Forest.*

Right: *Who knows who left this "memorial" along the highway near Liard Hotsprings Provincial Park, B.C.*

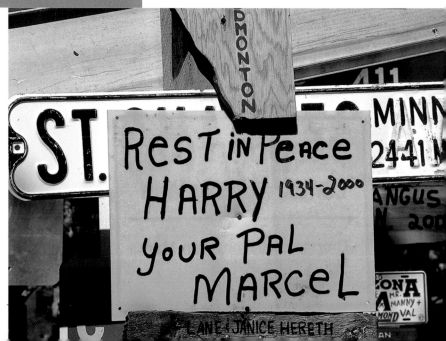

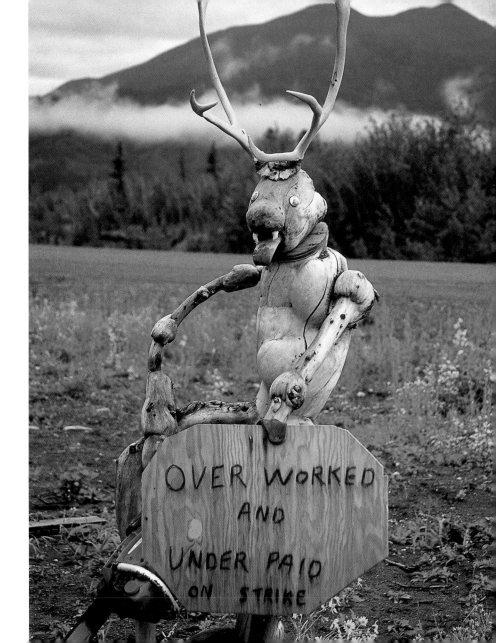

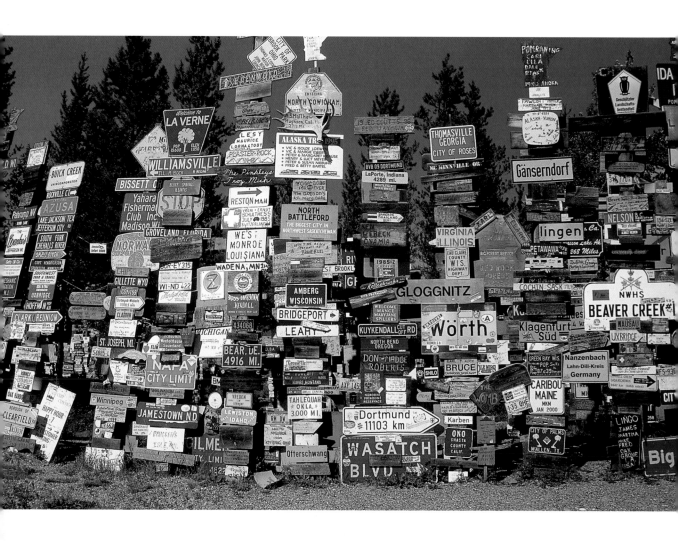

Left: *No forest anywhere is like this grove in Watson Lake's bizarre Signpost Forest.*

Right: *On the road again, campers have no worries over traffic congestion anywhere, anytime, on the Alaska Highway.*

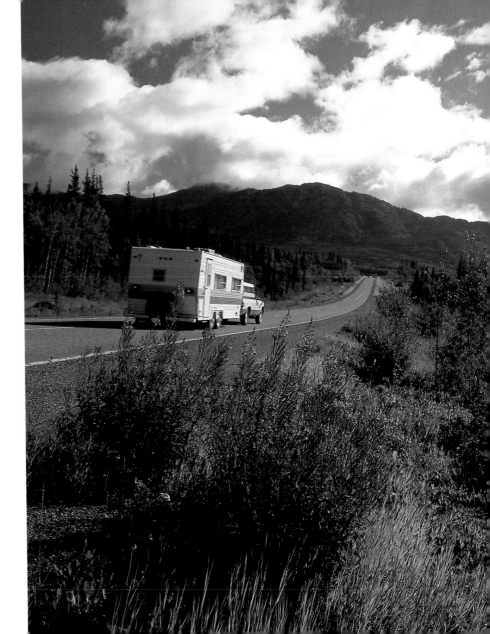

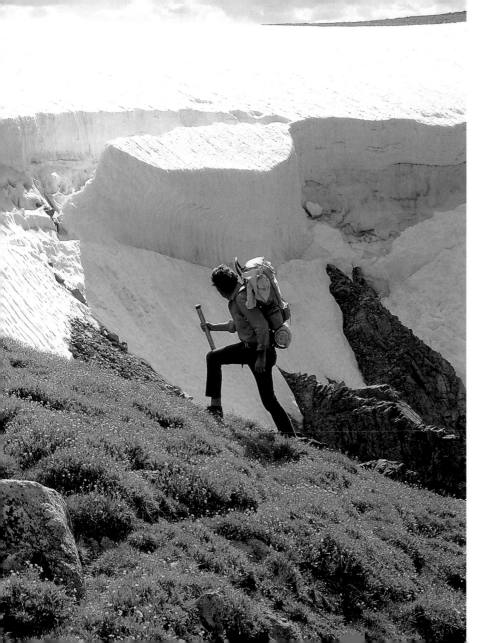

Left: *Hiking opportunities in Kluane National Park vary from easy, level trails to steep alpine climbs.*

Right: *Far off the highway, accessible by floatplane, are countless fishing lakes without names, like this one in British Columbia.*

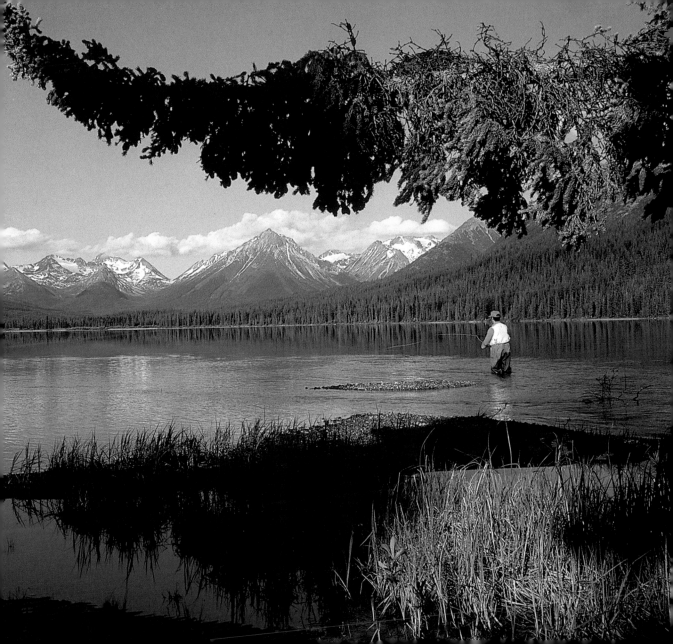

Far left: *One wonders how many miles this dog sled, long discarded, carried a musher and his gear over deep snow.*

Left: *A very skilled cabin builder meant this lodging to last forever.*

Right: *Salmon hang to dry from a sturdy, handsome cache along the highway in Alaska.*

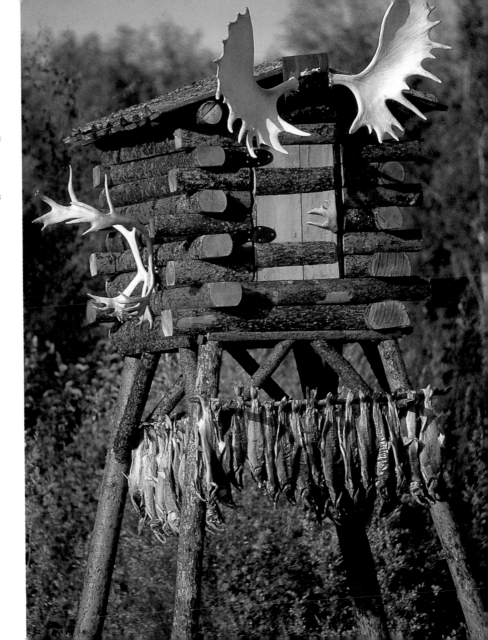

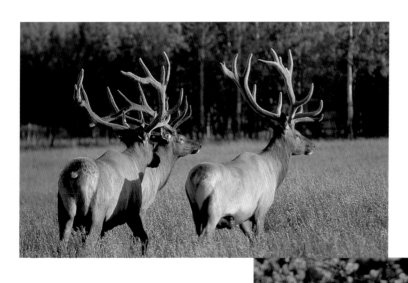

Above: *Since their recent introduction to the area, elk have become a common sight on the highway between Whitehorse and Haines Junction.*

Right: *Willow ptarmigan might be seen near the road's edge in open country, especially in early summer.*

Far right: *A wolf gives passers-by a quick glimpse before disappearing with a freshly caught ground squirrel.*

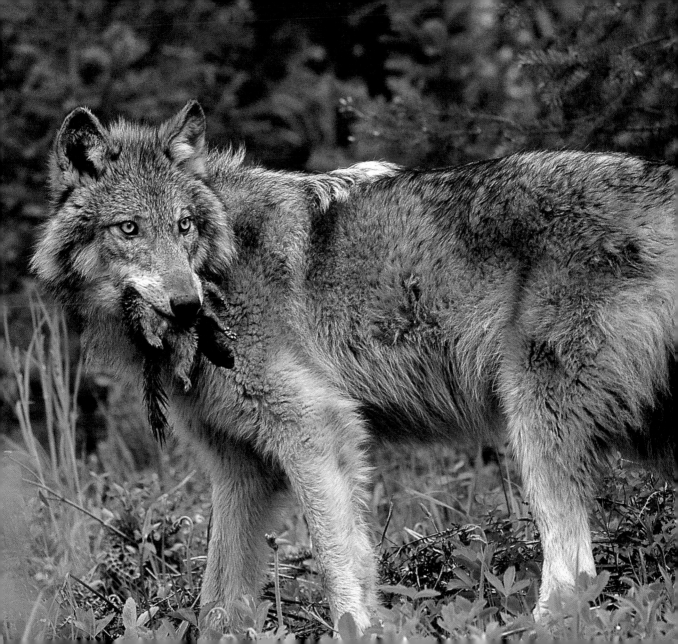

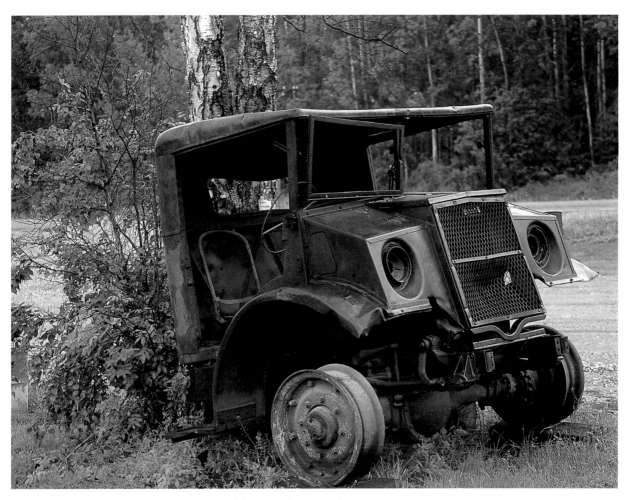

*Here and there, relics of original road
construction equipment used in 1942 stand
rusting and ghostlike along the highway.*

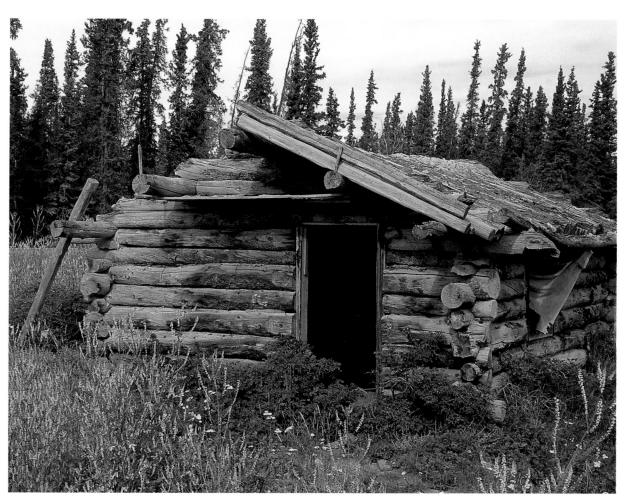

A homesteader's or trapper's cabin, near
Northway, Alaska, slowly disintegrates.

This autumn vista of the Tahkini River, which runs parallel to the highway west of Whitehorse, Yukon, will be covered with snow in a few weeks.

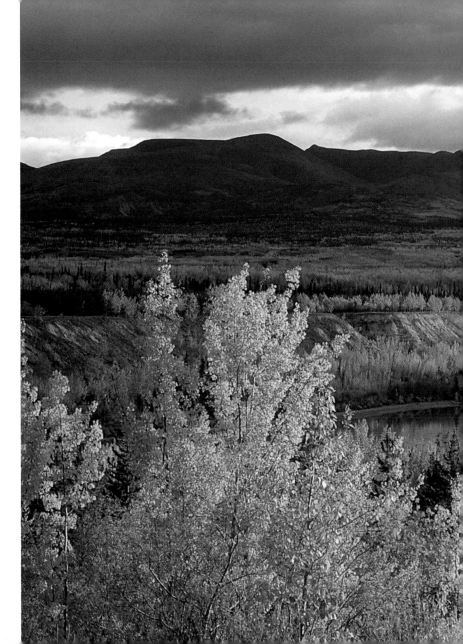

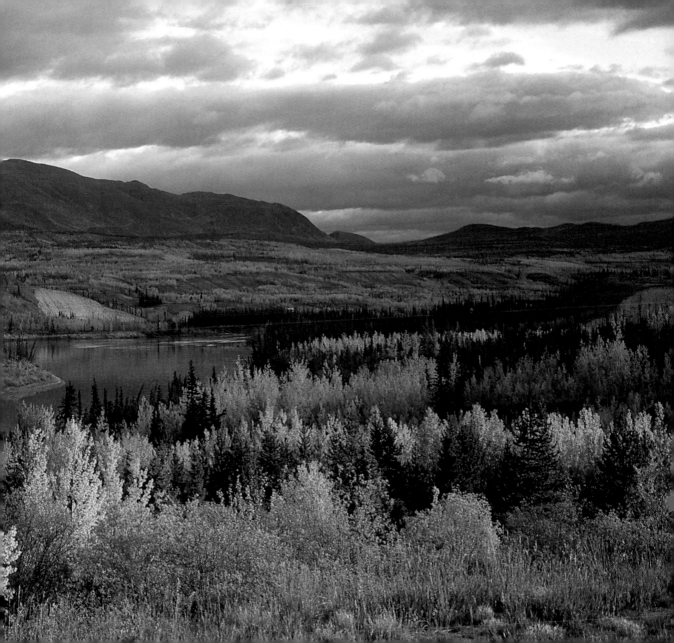

SELECT BIBLIOGRAPHY

Alaska Geographic Society. *Adventure Roads North: The Story of the Alaska Highway and Other Roads*, in *The Milepost*, No. 1,
 1983, Vol. 10.

Bauer, Erwin. *Wild Alaska*. New York: Outdoor Life Books, 1988.

———. *Denali: The Wild Beauty of Denali National Park*. Seattle: Sasquatch Books, 2000.

———. *Glacier Bay: The Wild Beauty of Glacier Bay National Park*. Seattle: Sasquatch Books, 2001.

———. *Bears of Alaska*. Seattle: Sasquatch Books, 2002.

Brown, Tricia. *The World-Famous Alaska Highway: A Guide to the Alcan & the Wilderness Roads of the North*. Golden,
 Colorado: Fulcrum Publishing, 2000.

Coates, Ken. *North to Alaska! Fifty Years on the World's Most Remarkable Highway*. New York: Diane Publishing, 1998.

Coates, K. S., and W. R. Morrison. *The Alaska Highway in World War II: The U.S. Army of Occupation in Canada's Northwest*.
 Norman: University of Oklahoma Press, 1992.

Dalby, Ron. *The Alaska Highway: An Insider's Guide*. Golden, Colorado: Fulcrum Publishing, 1993.

Haigh, Jane G. *The Alaska Highway: A Historic Photographic Journey*. Portland, Oregon: Graphic Arts Center Publishing, Co., 2000.

Morritt, Hope. *Land of the Fireweed: A Young Woman's Story of the Alaska Highway Construction Days*. Portland, Oregon:
 Epicenter Press, 1987.

Readicker-Henderson, Ed. *Adventure Guide to the Alaska Highway*. Edison, New Jersey: Hunter Publishing, 2001.

Stone, Ted. *Alaska and Yukon History Along the Highway*. Red Deer, Alberta: Red Deer College Press, 1997.

Twichell, Heath. *Northwest Epic: The Building of the Alaska Highway*. New York: St. Martin's Press, 1992.

Woodward, Caroline Hendrika. *Alaska Highway Two-Step*. Victoria, British Columbia; Polestar Book Publishers, 1973.

Yukon's Wildlife Viewing Guide. Government of Yukon Department of Renewable Resources, 1994.

Published by Sasquatch Books
Printed in Singapore by Star Standard Industries Pte Ltd.
Distributed by Publishers Group West
09 08 07 06 05 04 03 6 5 4 3 2 1

Cover and interior design: Karen Schober
Map: Linda Feltner

Library of Congress Cataloging in Publication Data
Bauer, Erwin A.
 The Alaska Highway : a portrait of the ultimate road trip / Erwin and Peggy Bauer.
 p. cm.
 ISBN 1-57061-285-4
 1. Alaska Highway—Description and travel. 2. Alaska Highway—Pictorial
 works. 3. Northwest, Canadian—Description and travel. 4. Northwest,
 Canadian—Pictorial works. 5. Alaska—Description and travel. 6.
 Alaska—Pictorial works. 7. Bauer, Erwin A.—Journeys—Alaska Highway. 8.
 Bauer, Peggy—Journeys—Alaska Highway. I. Bauer, Peggy. II. Title.

 F1060.92.B38 2002
 979.8—dc21 2001049704

Sasquatch Books
119 South Main Street, Suite 400
Seattle, Washington 98104
(206) 467-4300
www.sasquatchbooks.com
books@sasquatchbooks.com

ABOUT THE AUTHORS

Based on the Olympic Peninsula of Washington State, Erwin and Peggy Bauer are considered two of the world's premier wildlife photographers. A prolific husband-and-wife team—with 250,000 images in their photo file—the Bauers' photographs have appeared in nature magazines around the globe and graced more than 300 published covers. Together they have produced 45 books on wildlife and the outdoors. While the Bauers continue to travel all over the world to photograph animals and landscapes, they have developed a special relationship with Alaska in the last 25 years, where they return again and again. They are also the recipients of many awards, including most recently the prestigious North American Nature Photography Association's 2000 Lifetime Achievement Award.